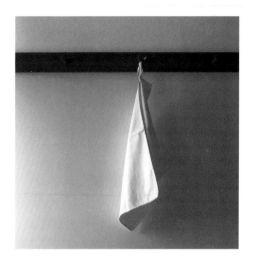

A PLACE IN TIME

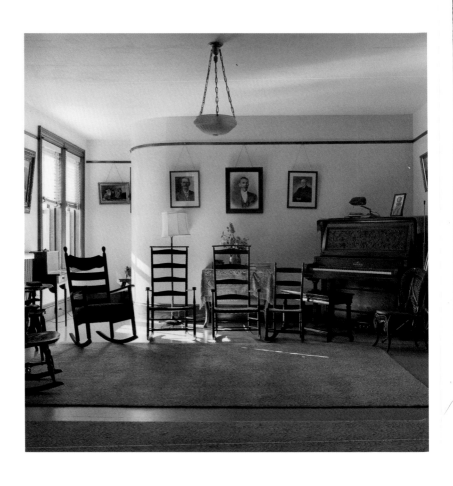

Music Room. Dwelling House, 1972

A PLACE IN TIME

The Shakers at Sabbathday Lake, Maine

Photographs by STEPHEN GUION WILLIAMS

Foreword by GERARD C. WERTKIN

ℙ A POCKET PARAGON BOOK
DAVID R. GODINE · *Publisher* · *Boston*

This is a Pocket Paragon Book
published in 2006 by
DAVID R. GODINE · *Publisher*
Post Office Box 450
Jaffrey, New Hampshire 03452
www.godine.com

Page 1: *Towel Drying, Dwelling House, 1972*
Page 5: *Morning Mist, Dawn, Summer, 2005*

LIBRARY OF CONGRESS CATALOGING-IN-PUBLICATION DATA
Williams, Stephen Guion, 1942–
A place in time : the Shakers at Sabbathday Lake, Maine / photographs
by Stephen Guion Williams ; foreword by Gerard C. Wertkin.— 1st ed.
p. cm.
"A Pocket Paragon book."
ISBN-13: 978-1-56792-310-0 (softcover : alk. paper)
ISBN-10: 1-56792-310-0 (softcover : alk. paper)
1. Shakers—Maine—Sabbathday Lake—Pictorial works.
2. Sabbathday Lake (Me.)—Pictorial works. I. Title.
BX9768.S2W55 2006
289'.80974191—dc22
2005037017

FIRST EDITION
Printed in China by Everbest Printing

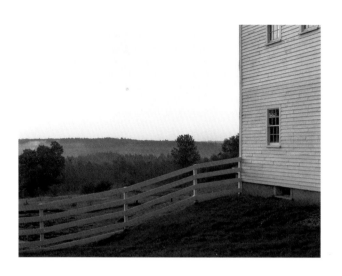

For Donna, my lovely wife,

partner, companion, and guide to our marvelous journey,

one filled with love and Spirit.

With you all things are possible.

Thank you, my love.

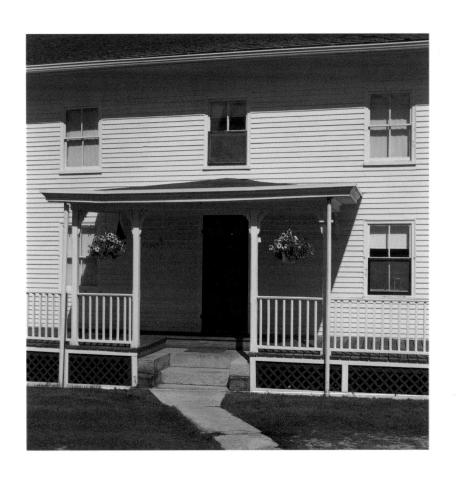

Wash House Entrance, 2002

The nine-mile stretch of Route 26 north of the town of Gray in south central Maine no longer runs its course through a rural landscape. To be sure, the road still offers fleeting glimpses of beautiful lakes, glistening in the sun on a bright day, and the original character of the place is suggested by the presence of a tiny country graveyard and an old Grange Hall. But even to a casual traveler it would be clear that growth and development are bringing change to this quiet hinterland – that is, until the road rises along a sloping hill, and a sweeping view of Shaker Village greets the eye. Nestled in a striking 1700-acre setting of timberland and woods, meadows and pastures, vegetable gardens and apple orchards, and called Sabbathday Lake for the lovely body of water that lies on its lands, the nation's only surviving Shaker community exists comfortably in its own ways.

The community is small. There are only four covenanted members, Eldress Frances A. Carr, Brother Arnold Hadd, Brother Wayne Smith and Sister June Carpenter, and a novitiate member or two, but their numbers are augmented by others. Dedicated volunteers are present in the village throughout the year, not infrequently for weeks at a time, and a small professional staff assists the Shakers in operating their museum and maintaining the research library. Indeed, any temptation to describe today's Shakers as a mere remnant is quickly dispelled if one views the full scope of their daily activities and outreach.

In this handsome volume, Stephen G. Williams evokes the timeless quality of daily life at Shaker Village, and through the

sensitive composition of his splendid photographs, opens doors to a more profound experience of its textures and moods. The Sabbathday Lake Shakers maintain a museum in their village, but it is the living community that interests him more, perhaps because he has known the Shakers most of his life. His first photographic study of the community, *Chosen Land: The Sabbathday Lake Shakers*, was published in 1975. Then and now, Williams asks us to look beyond Shaker architecture and design, which are so widely admired in the world, and seek to discover in the simplicity of the daily rounds a key to the Shaker ideal.

The origins of the faith that continues to shape life at Sabbathday Lake may be traced to mid-eighteenth-century Lancashire, and to the gatherings – beginning about 1747 – of a small, loosely organized group of petty tradesmen and artisans who, as religious dissenters, rejected the formal liturgical traditions of the Church of England. Seeking a freer, more personal expression of Christian faith, they became known as "Shakers" or "Shaking Quakers" for their ecstatic worship practices, which, according to one account, included "singing, shouting and leaping for joy." The first Shakers were deeply affected by a sense of God's immanence in a lost and sinful world and were drawn to millenarian prophecy and speculation about the Second Coming of Christ. But for the most part they did not articulate a fixed creed or dogma.

Ann Lee (1736–1784), the daughter of a Manchester blacksmith and a member of the Anglican communion, found a spiritual home among the Shakers in 1758. A person of great strength of character, deep conviction and personal charisma, she not only became leader of the nascent group, but also was

8

so influential in the development of its religious faith and practice that she was soon recognized as its founder. Mother Ann – as her followers called her – could neither read nor write. But collections of her teachings or "precepts" were gathered by the Shakers after her death and continue to be referred to for ethical guidance and moral direction by the sisters and brethren at Sabbathday Lake to this day.

Because of the noisy exuberance of their worship forms, the first Shakers attracted the hostility of their neighbors and the English civil and ecclesiastical authorities; several Shakers, including Ann Lee herself, were fined or imprisoned in the early 1770s. Then, in 1774, Mother Ann led a small group of Shakers to America. Among those who took the long sea voyage with her were her brother, William Lee, and her young disciple, James Whittaker, who had become important advocates of the new faith. The members of the group scattered for their first two years in the country, but came together in 1776 in the dense wilderness of Niskayuna, New York, near Albany. Notwithstanding the harshness of their surroundings, they cleared the land for farming and rendered it suitable for a home. In 1780, in response to the "New Light" religious revival that was sweeping the countryside along the New York–Massachusetts border, the Shakers began their public ministry.

During the next four years, Ann Lee and her companions undertook preaching journeys in upstate New York and New England. By the time of her death in 1784, the groundwork had been laid for the organization of Shaker communities throughout the region and beyond. Under Mother Ann's American-born successors, Joseph Meacham and Lucy Wright, Shakerism was established in New York, Connecticut, Massachusetts,

New Hampshire, Maine, Kentucky, Ohio and Indiana, as well as in smaller, short-lived communities in those and other states. Sabbathday Lake, one of the smallest of nineteen principal Shaker sites, was formally organized or "called into Gospel order" on April 19, 1794, although its roots lie even deeper in Shaker history.

In their self-contained villages, the members of the United Society of Believers in Christ's Second Appearing, as the Shakers became formally known, practiced celibacy, separation from the world, communal ownership of property, pacifism, and confession of sin, all of which they based on the New Testament accounts of the life and teachings of Jesus. It is sometimes suggested that the Shakers have Bible-like scriptures of their own but this is an erroneous assumption; in fact, readings from the Bible are at the heart of Shaker worship, both on Sunday and during the week. Williams captures the mood of Shaker daily prayer in one of his affectingly intimate photographs of community life. In another photograph, an open Bible and a schedule of Bible readings grace the breakfast table.

As a distinctive Shaker theology developed, the Believers began to understand the one God both in female and male terms, as Mother and Father. The equality that Shaker sisters and brethren enjoyed in the various departments of community life and leadership was a practical application of this idea, although gender-related work patterns tended to mirror the practices of the world, and celibacy imposed a degree of separation on them. Indeed, separate doors and staircases were the rule for men and women in dwellings, meeting houses and the other buildings that they shared. Today's Sabbathday Lake Shakers continue to observe these time-honored traditions.

As depicted in a striking photograph by Williams, sisters and brethren use one of two side-by-side doors, to enter and leave the winter chapel or meeting room of the central brick dwellinghouse.

At its height in the first half of the nineteenth century, the United Society counted fewer than five thousand members in all of its branches combined. At first reviled by their suspicious neighbors, the Shakers in time were admired for their neat, efficient farms, the excellence of their products, their innovative technology, and the genius for invention that marked their history. They pioneered the packaging of garden seeds for sale, produced a wide variety of pharmaceutical products and were widely acknowledged as progressive farmers, builders and manufacturers. The Sabbathday Lake Shakers continue to produce herbal products for sale – including a popular potpourri that follows the recipe of a nineteenth-century Shaker leader, Eldress Hester Ann Adams.

Dozens of patents were awarded to Shakers for various technological innovations, and an emphasis on simplicity, harmony and perfection within the communities prompted the development of a distinctive tradition in the arts and crafts, notable for its paring down of vernacular forms. At Shaker Village today, many of the finest examples of Shaker furniture are on public display in the community's museum, although as Williams's interior photographs demonstrate, Shaker-made objects still find use in daily life at Shaker Village together with objects of worldly origin. A quiet bedroom photographed by Williams does not contain a single Shaker object, but the spirit of the room is no less simple or contemplative. Oval boxes of various sizes have been a staple of Shaker manufacture

for two centuries; Williams depicts the rebirth of this craft among today's Shakers.

The Shakers created a distinctive folk hymnody at once hauntingly beautiful and quick and spirited, and that gave special character to their religious services. Hundreds of songs remain in the repertoire of the Sabbathday Lake Shakers, and they have taken this musical tradition across the country through personal appearances and recordings. Elaborate dance forms and marches evolved out of earlier, unprogrammed movements of worship are no longer performed, but traditional "motioning" still accompanies the singing of certain songs.

By the mid-nineteenth century, a slow but unremitting disintegration, the result largely of a failure in leadership, began to affect the Shaker villages until, one by one, they closed. Even an exceptional ten- or fifteen-year period of revival beginning in 1837, known variously as the Era of Manifestations or Mother's Work, did not stem the decline. By the beginning of the twentieth century, many of the villages relied for continuity on the children, primarily orphans and unwanted infants, left with the Shakers. Only three villages survived into the second half of the twentieth century – Hancock, Massachusetts; Canterbury, New Hampshire; and Sabbathday Lake, Maine. Today only Sabbathday Lake remains as an active center of the Shaker faith.

The Shaker survival in Maine must be accounted as a small miracle. The faith was first brought to the region in 1782, when it was little more than a remote wilderness. Three missionaries from Gorham, Maine, themselves new Believers, came to preach among country folk caught up in a frontier revival. Eventually members of the Briggs, Holmes, Merrill and other

local families entered the community in large numbers. The first properties to comprise Shaker Village were within the southeastern limits of Thompson's Pond Plantation, a narrow, unincorporated strip of land. Portions of Thompson's Pond Plantation were later annexed to several adjacent towns and Shaker Village became part of New Gloucester in 1816.

Both geographic and economic factors contributed to the longevity of the Sabbathday Lake community. Although among the poorest of the Shaker villages, it was also the farthest north. Its location reinforced a kind of Yankee determination long associated with the New England backcountry. In the early twentieth century, when other Shaker communities were abandoning the distinctive practices of the church – meeting for worship, the yearly fast day, the annual reading of the Shaker Covenant – the Maine Shakers stubbornly maintained them. Competent management of resources by such latter-day leaders as Eldress Elizabeth Noyes, Eldress Prudence Stickney, Elder William Dumont and Brother Delmer C. Wilson was certainly a factor in survival, as was the merger of Sabbathday Lake with Maine's other Shaker community, at Alfred, in 1931. But these factors alone would not have insured survival if it were not for an unbroken line of revered teachers and leaders who, even in this century, continued to excite in new generations the spiritual possibilities of a life dedicated wholly to God. Beautiful souls like Sister Aurelia G. Mace, Eldress Fannie Casey, Eldress Harriett Coolbroth, Sister R. Mildred Barker, Brother Theodore E. Johnson and Eldress Frances A. Carr constitute an unbroken chain of faith that provided the real strength of Shakerism in Maine. In some of Williams's most affecting interior compositions, framed photographs of

some of these Shaker leaders may be seen in places of honor.

The distinctive heritage of the Maine Shakers seems to have provided a fuller context for living the Shaker life in a changing world. While other sites have been transformed into museum villages or converted to institutional, residential or other uses, Sabbathday Lake is still a Shaker village and its members still live a Shaker life. Their beautiful home may have the qualities associated with a museum, but its twelve major buildings house a community that remains active and alive. In her afterword to Stephen Williams's first photographic study of Sabbathday Lake, the late Sister R. Mildred Barker (1897–1990) observed that there is, perhaps, "no other place in our country where one receives so strongly the impression of a particular way of life having been lived for so long and with so great faithfulness as at Sabbathday Lake." And yet, with continuity comes change. "Unlike museums and restorations," she wrote, "Sabbathday Lake stands as a unique example of an ever-changing response to the world and its demands."

Shakers are not born into their faith. By its celibate nature, they must come to a personal decision whether to accept it or not. "Chosen Land," the spiritual name given to the Sabbathday Lake Shaker Village during the mid-nineteenth-century period of revival and still in use today, captures the very essence of the Believers' consecration. At the heart of the Shaker ideal is simplicity, a paring away of artifice and conceit to realize true freedom. That ideal – which finds expression at every turn in Shaker Village – is eloquently captured by Stephen G. Williams on the pages of this book.

Today's Shakers open their doors to the world. Dozens of friends regularly attend meetings for worship with them, many

dozens more are frequent visitors and helpers, and thousands come to see their museum. Their influence profoundly transcends their very small numbers. And despite continual attention from interested outsiders, they remain true to the ideals of their heritage. There is no arrogance or self-righteousness among them. They live lives of dedicated service and simplicity. They have little concern for the future. When asked, they will say that the future of their community is dependent upon the will of Providence. In the meantime, they continue to do God's work, as they understand it.

GERARD C. WERTKIN, *Director*
American Folk Art Museum, New York

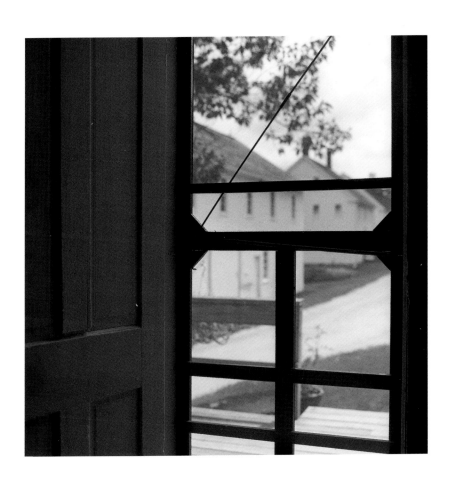

Kitchen Entrance Looking Outside, Dwelling House, 2002

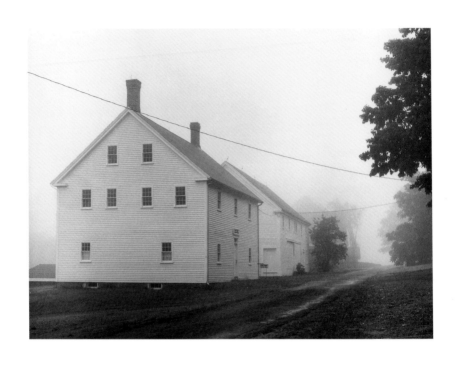

Early Morning Fog, Spring, 1972

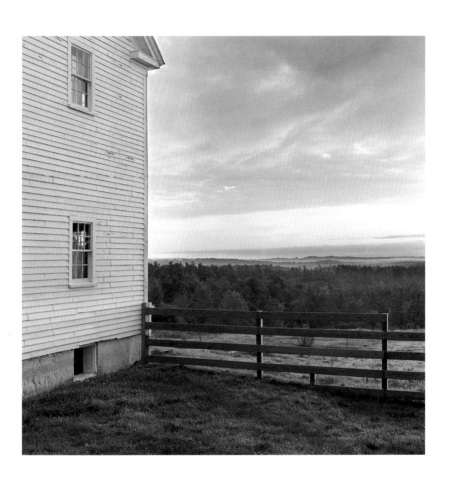

Early Morning Storm, Summer, 2002

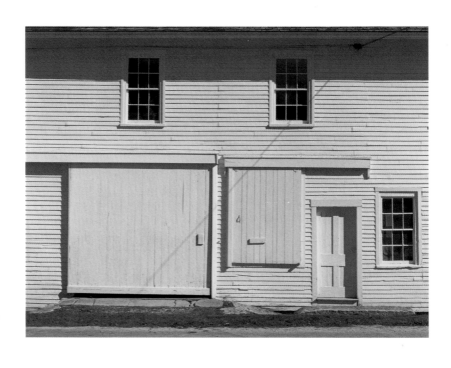

Barnside, Noontime, 2002

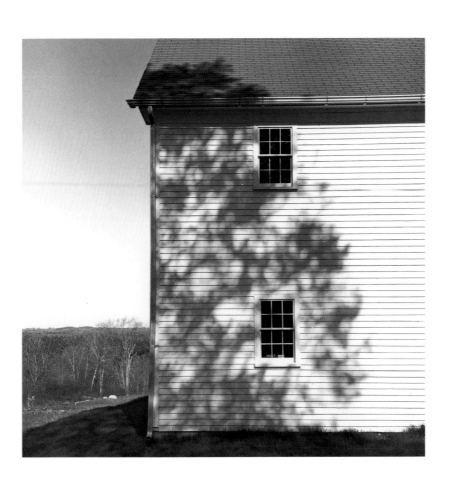

Shadow on Building, 1972

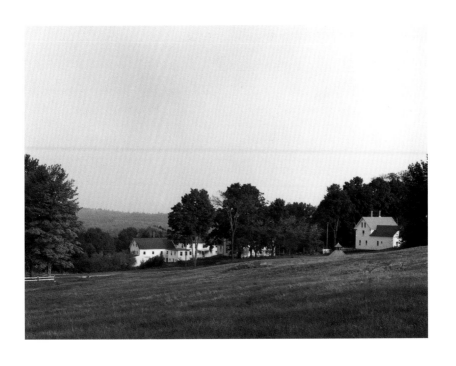

Eastern View, 1972

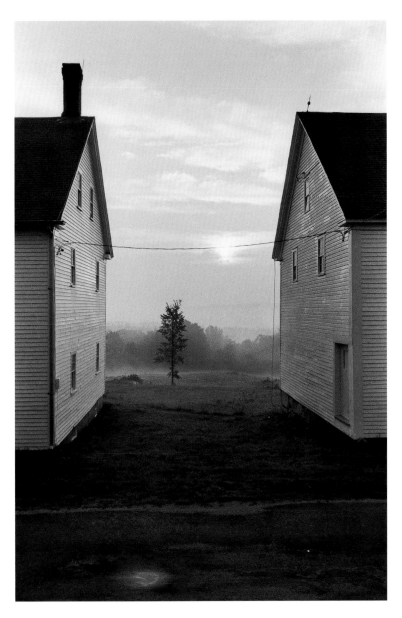

Sunrise, Chosen Land, 1972

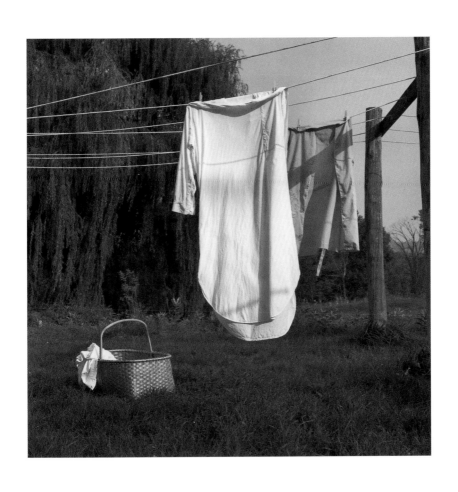

Nightshirt Drying Outside the Wash House, 1972

27

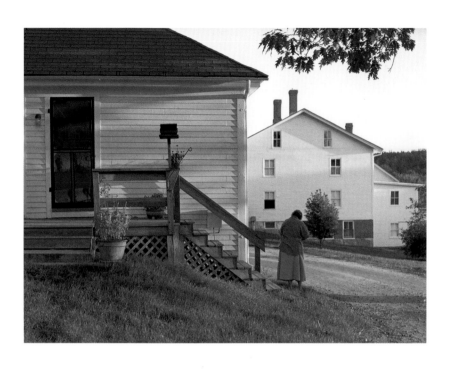

Sister June Feeding Birds, Early Morning, 2002

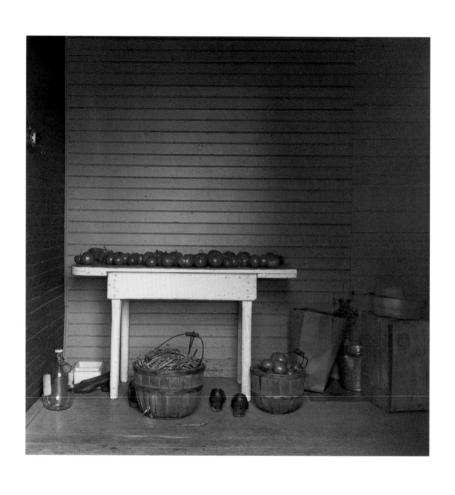

Tomato Harvest, Kitchen, Side Entrance, 1972

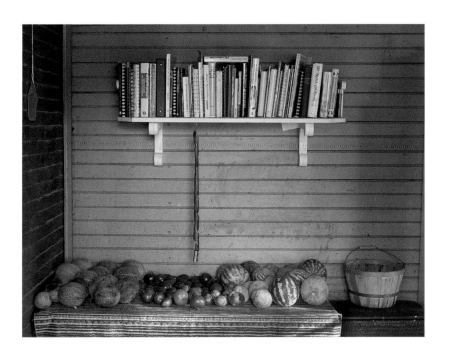

Summer Harvest and Books, Kitchen, Side Entrance, 2002

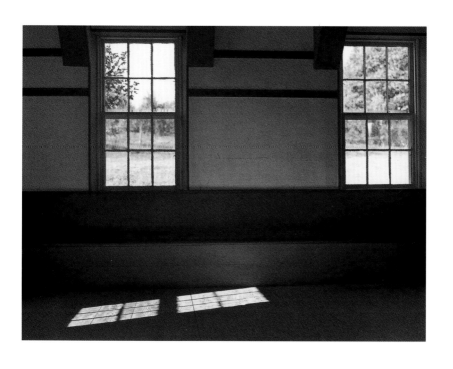

Meeting House, Afternoon, 2002

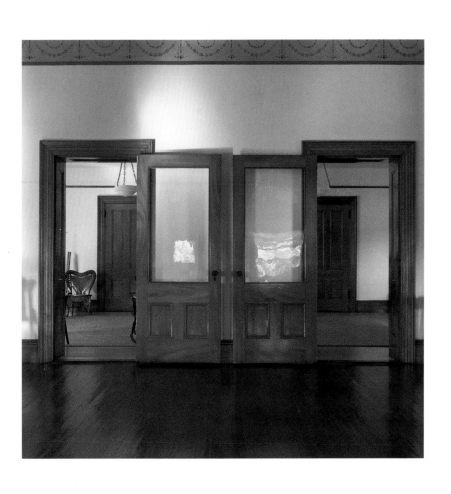

Chapel Doors, Sunday Morning, 1972

35

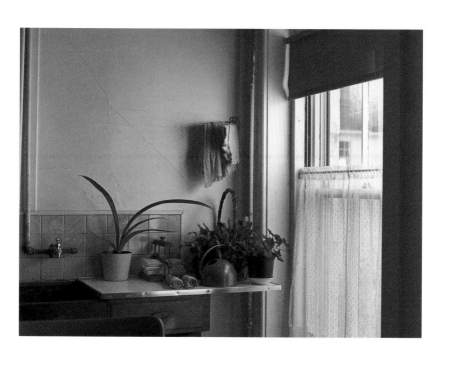

Dining Room, Dwelling House, Morning, 2002

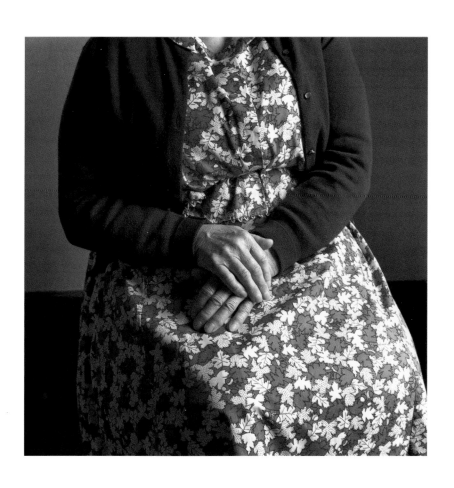

Sister Elsie, Dining Room, Dwelling House, 1972

39

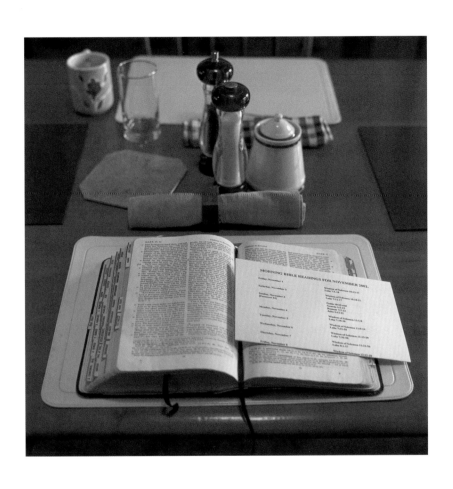

Morning Prayers, Dining Room, Dwelling House, 2002

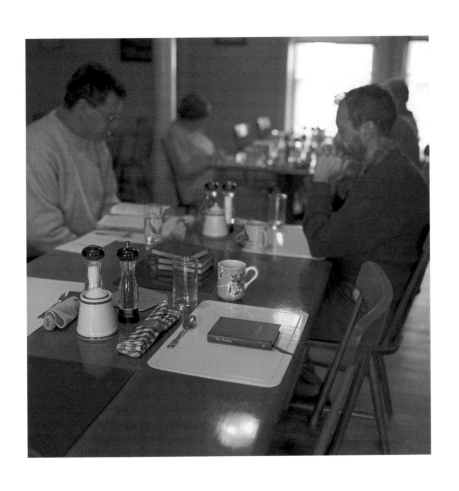

Brother Wayne, Brother Arnold, Morning Prayers, 2002

43

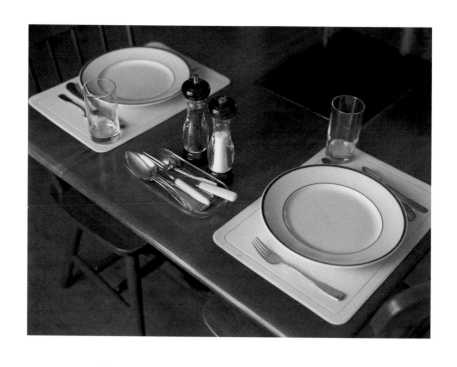

Place Settings, Dining Room, Dwelling House, 2002

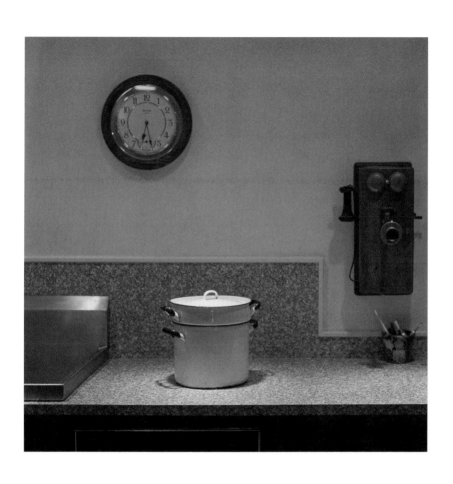

Kitchen, Dwelling House, 2002

45

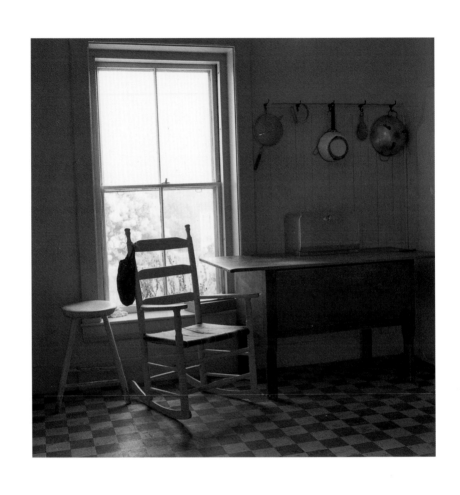

Rocker and Bread Board, Kitchen, 1972

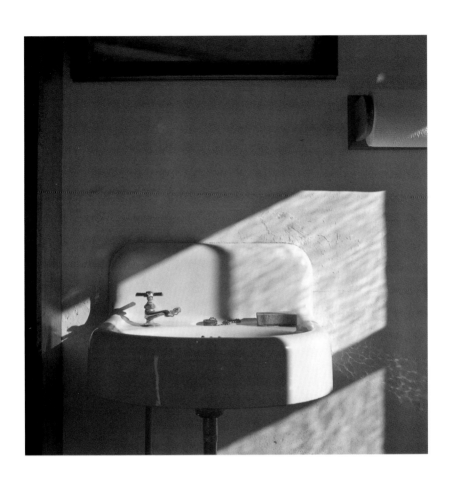

Wash Sink, Brethren's Waiting Room, 2002

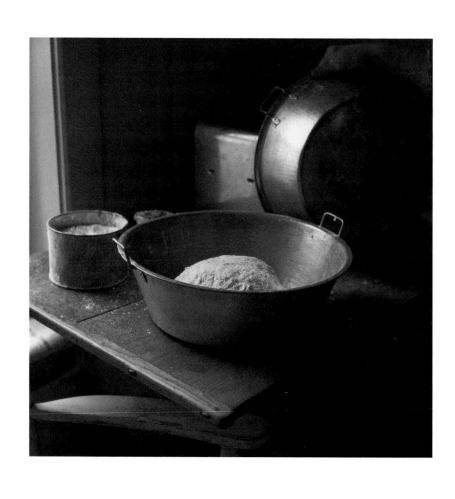

Bread Dough Rising, Kitchen, 1972

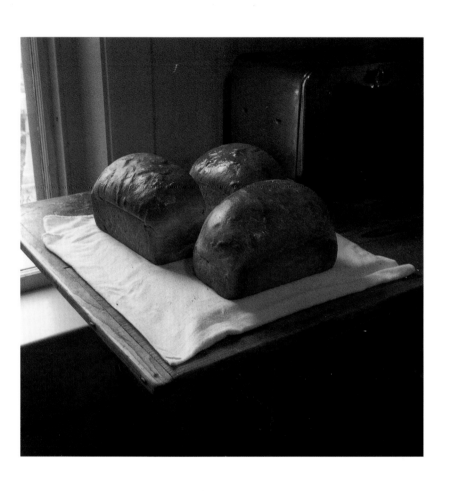

Finished Loaves, Kitchen, 1972

49

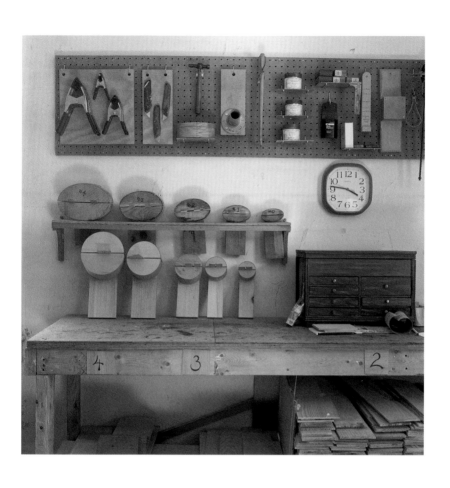

Wooden Oval Box Forms, Wash House, 2002

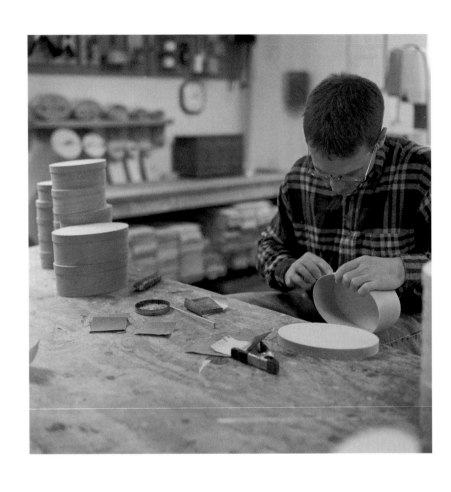

Michael, Oval Box Construction, Wash House, 2002

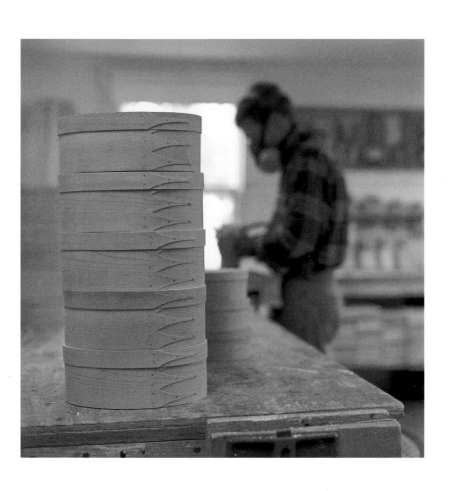

Completed Oval Boxes, Wash House, 2002

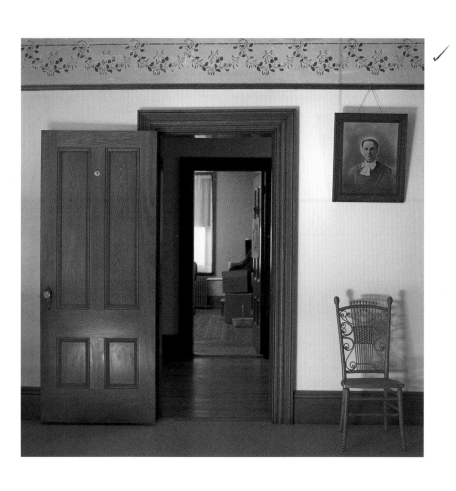

Second Floor, Dwelling House, 2002

55

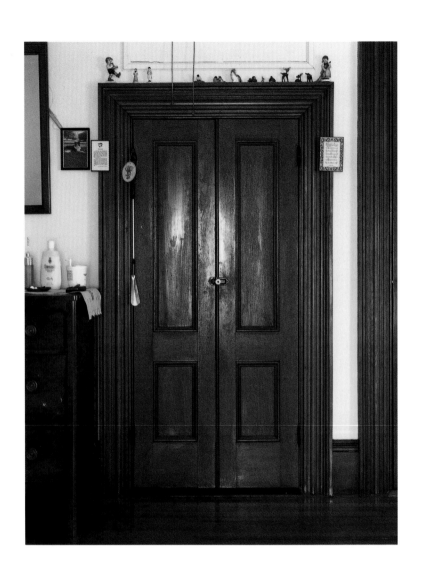

Sister Mildred's Bedroom, Dwelling House, 1972

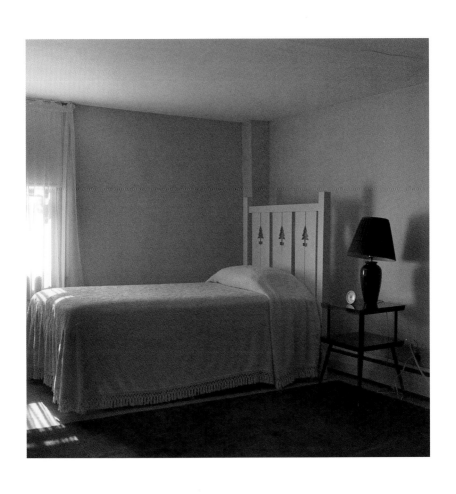

Guest Room, Entrance Building, 2002

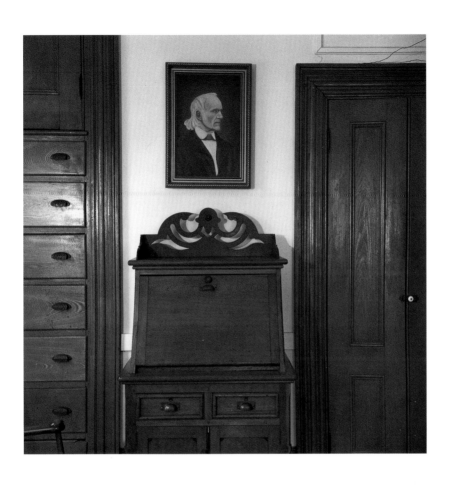

Second Floor, Dwelling House, 1972

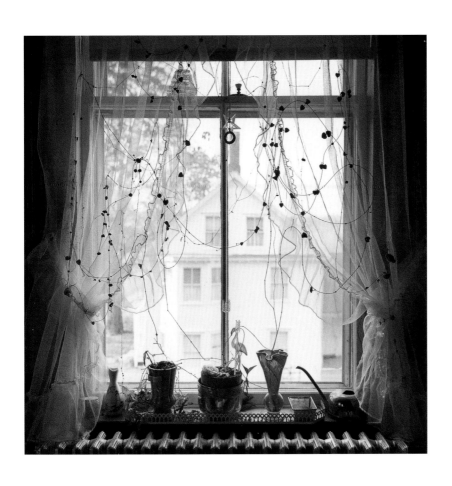

Dwelling House Bedroom, 1972

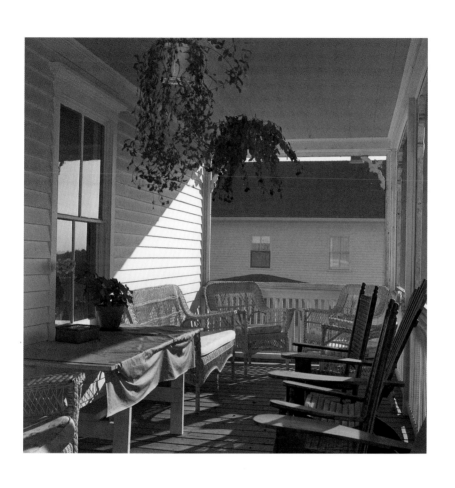

Office Entrance, Porch, 2002

63

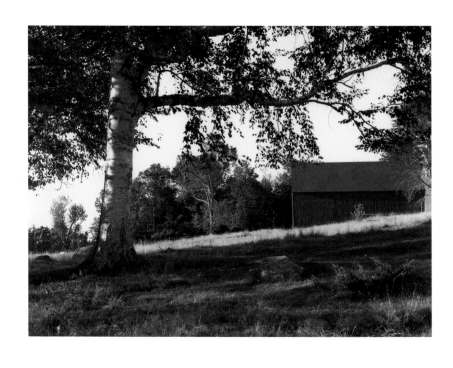

Eastern View, Cattle Barn, 2005

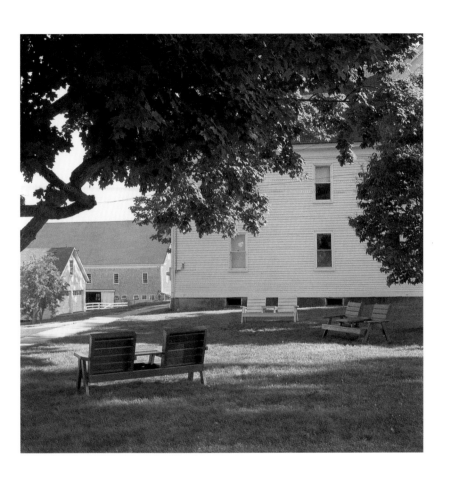

Three Benches, Late Afternoon, 2002

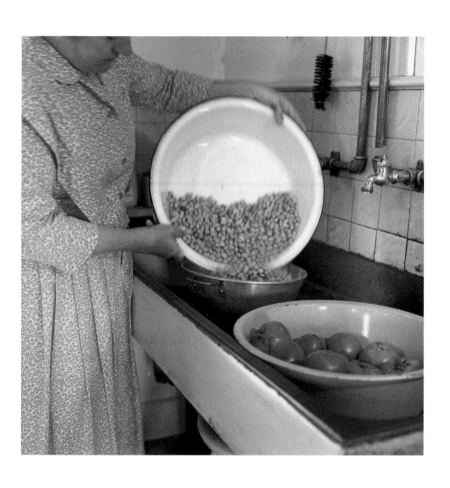

Food Preparations, Sister Francis, Kitchen, 1972

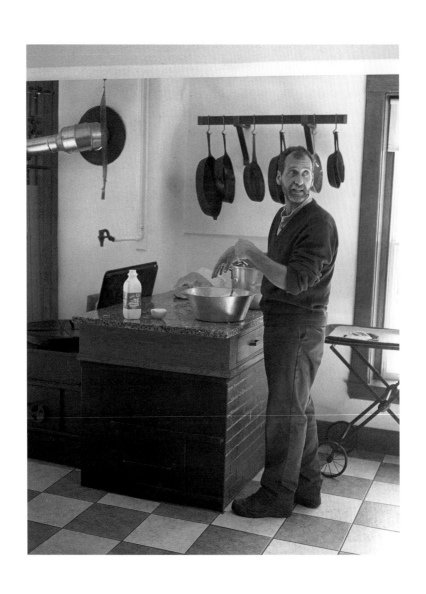

Food Preparations, Brother Arnold, 2002

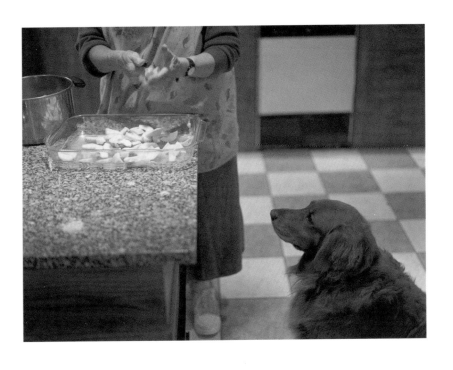

Chase and Sister Francis, Kitchen, 2002

69

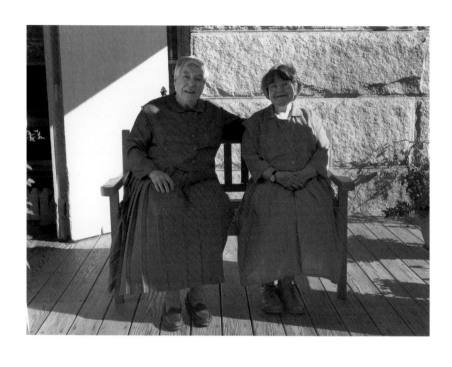

Sister Francis and Sister June, Saturday Morning, 2005

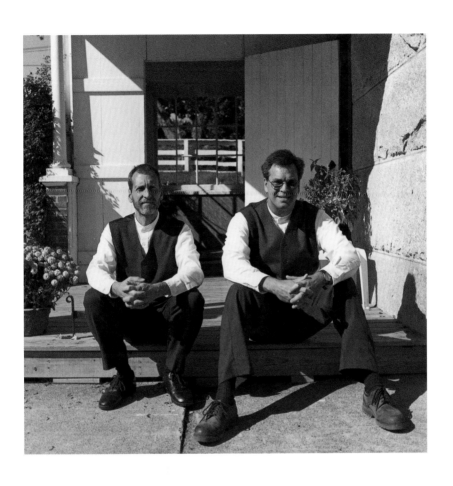

Brother Arnold and Brother Wayne, 2002

71

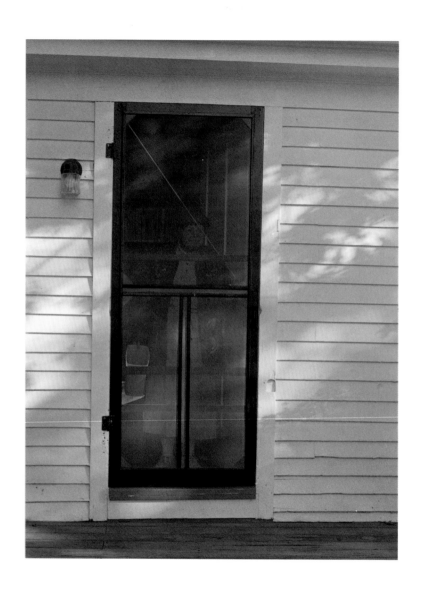

Sister June, Side Entrance, 2002

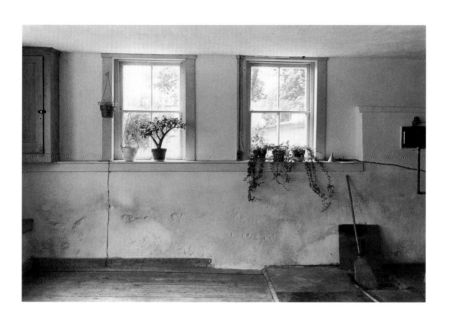

Interior, Wash House, 1972

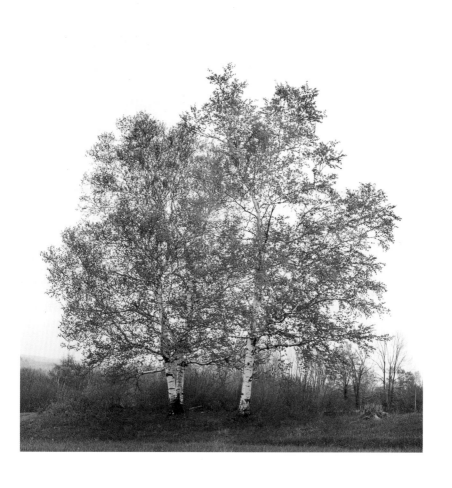

Two Trees, Afternoon, 1972

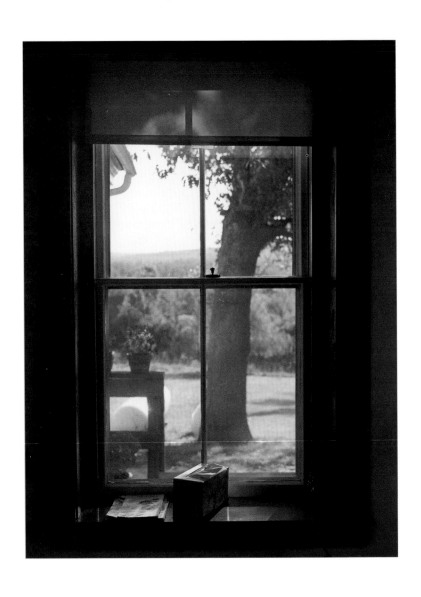

Kitchen window, Dwelling House, 2002

AFTERWORD

Photography, the Shakers, and Dad

Making pictures was the first thing I got right in life. I was a poor student in school, and it seemed I could never complete projects. Nothing stuck. But when I picked up my first camera (a used Yashica Mat) and began to expose negatives, photography became my language. Camera work felt natural to me. I connected with it, both technically and creatively.

I realized that my primary approach to the world was visual and suspected this had always been the case. Perhaps I trusted my visual instincts more than my verbal abilities, but at that point I understood one thing for sure: I could extract a picture from a scene and put it on film. A selection from the whole. "You've got a good eye," my father said. I liked the sound of that. Photography had given me an identity.

And so it began. When I was twenty-two, I freelanced as a staff photographer for the school newspaper at the University of Kansas, the *Daily Kansan*. In the basement darkroom of Flint Hall, my classmate and fellow photographer Roy Inman tutored me in the basics of processing film and making prints. I was a raw talent in love with the medium and Roy could not teach me fast enough.

On two occasions we drove to the University of Missouri to meet Cliff Edom, the photography teacher at the school of journalism. Cliff urged me to enroll in the Missouri Photography Workshops, which he directed every year. I did so twice, and it was there that my training as a photographer really took

shape as I worked alongside photographers from *Life*, *National Geographic*, *Sports Illustrated*, and the *New York Times*. It was a trial by fire, but I found the power to stir the viewer's emotions through a series of images very exciting.

About this time, I discovered the photo essays of W. Eugene Smith, whose photographic profile of Dr. Albert Schweitzer, published in *Life* magazine, powerfully evoked both subject and photographer. I pored over Gene's stories until I had memorized every image and how they were used in the layouts. To this day I am stunned by his compositions.

Many years later, Gene was one of the early lecturers at The Photography Place, a gallery, workshop, and darkroom facility Tom Davies and I established in 1970 in Berwyn, Pennsylvania. One of the first institutions of its kind in the country, The Photography Place offered workshops with master photographers and exhibited their work. Eugene Smith was among the first, then Arnold Newman, Lee Friedlander, George Tice, Emmit Gowin, Garry Winogrand, and many other (at that time) emerging photographers. Gene did not then know that he had been among my role models. I could not, in the presence of one of the giants of photography, tell him so. Only now can I say, "Thank you, Gene."

Paul Caponigro also conducted a workshop during that first year. I had met Paul on two occasions about five years apart, and both times he had looked at my work. His thoughtfulness and sensitivity – not only in viewing my work but also in understanding my immaturity – helped me grow.

I had not really studied Paul's work nor did I yet understand him as a person. At that workshop I was impressed by his quiet presence and, even more so, by the prints he showed

us that Saturday morning. He displayed some twenty-five prints from his early Stonehenge photographs. They were so ethereal, so silvery in their quality. For me they resonated with Paul's being. I had never been so moved by a set of prints. Paul did not speak much during his presentation: the images were his pure artistic expression. I remember thinking at that time how completely different this was from my photojournalistic experience. Paul had developed the camera as a powerful and intimate instrument, a pure extension of his mind and esthetics.

One year later, in June 1971, I attended Ansel Adams's workshop in Yosemite, California, a trip that provided a key experience in my emergence as a photographer.

At Yosemite, I had the good fortune of a private visit with Ansel early one morning. An invitation had been arranged by my good friend George Salvarian, who had befriended the master photographer during a critique session a few days earlier. Ansel welcomed us at his studio and immediately ushered us into his darkroom. Classical music was playing. The floor was carpeted. Ansel had a 20 x 24″ print in the wash. I was mesmerized! Ansel briskly asked us if we would like to print. Without hesitation, George accepted for both of us and, for the next three hours, we became Ansel's apprentices.

We learned to read and interpret the density of negatives and how to print those negatives with the sophisticated enlarger Ansel used to make his famous large-scale prints. At the end of the session, Ansel asked us to comment on the finished prints, particularly in terms of the gradation of tonalities. I was entranced by his remarkable creativity, his technical acumen, and the sheer magic of his movements. What a joyful experience!

What has stuck with me all these years, however, was the

quiet respect he gave to the whole process. Ansel treated photography with reverence. His attitude toward his craft more than anything, was the most important lesson of that day.

My photography springs from the combined influence of these three artists. I am grateful to have met them and to have learned their values at first hand.

From Eugene I learned to never stop moving. Get close, then closer. Never lose sight of the story. Be sure you tell the story. From Paul I learned to respect the medium. Be open to a surprise, the "aha" experience. Trust your instincts. From Ansel I learned to "see" an image. Visualize the print. Take in the living landscape on all sides. Allow some part of the creative process to remain a mystery. All this – and there is so much more – yielded for me a life rich in detail and texture. I am truly grateful.

I now work as a family therapist. It's a wonderful career and I'm privileged to work in such a challenging field. I visit families in their homes on a weekly basis. I listen to their stories and observe their responses. I watch for interruptions in the rhythm of family life as the members struggle with the questions they direct toward one another. I look for the essence of those moments. Perhaps that is, as Henri Cartier-Bresson once said, "the alignment of mind, heart, and eye" that can frame the solution to a conflict within a family or the composition sought by the photographer.

* * *

My long involvement with the American Shakers is inseparable from my life in photography. I learned to use a camera and film competently as I documented the Sabbathday Lake community

when I was a young man. It was my first attempt at blending art and documentary images.

Earlier still, when I was an teenager, I traveled to Maine with my father in his tan Buick four-door. Dad had begun collecting Shaker tools as examples of craftsmanship when I was still a boy – one of the earliest collections of Shaker artifacts. From that modest beginning, he became intensely interested in the full range of objects made and used by the Shakers, going on to collect them with an eye toward opening his collection to the public.

On those car trips I was able to see and feel my father's genuine presence. It seemed to me that Dad was a somewhat shy and reserved man. There wasn't much conversation between us during our trips, but I could see his emotional restraint fade as we traveled, and I was closest to him during those moments.

Over the course of his many trips to the village, he had become particularly close to Sister Mildred Barker. During our visits, I would often be entertained in the kitchen with fresh rhubarb pie and an occasional hymn sung by Sister Francis and Sister Elsie. Dad would be upstairs visiting with Sister Mildred in the office. I often returned to Sabbathday Lake with my father as his vision of preservating something of their disappearing culture grew to be the single purpose in his life.

Today the Shaker Museum and Library – across the road from my childhood home in Old Chatham, New York – houses sixty-six thousand items my father collected. It is recognized as the premier Shaker collection in the world. Was my father a visionary? Did he feel a spiritual link to the Shakers? I think so, and I know for sure it is where my father found his identity.

*　*　*

When I began to think about a photographic story that I could publish in book form, I felt it was important to choose a familiar subject. A story that was personal. The Shakers provided me with an opportunity. More significantly, I realized that, on another level, my engagement with the Sabbathday Lake community allowed me a continued relationship with my father. That's the real story here: a gift from my father.

These two motives – my photography and my father's preservationist instincts – continue to drive me. From photography, I learned the importance of observation and the art of evaluating the frame. From my time among the Shakers, I learned simplicity of thought and balance of form.

These photographs document the strength and perseverance of the communit known as Sabbathday Lake or Chosen Land, the last active Shaker community in the world. Life here seems to progress unaltered or with only incremental change. I can feel the natural weight of that continuity and take great comfort in it. A sense of purpose remains steadfastly in place. When I visit the Shakers and partake of their daily rituals, I feel the presence of grace. Within this sense of grace there is a clear divine influence and – more importantly – a quiet, unobtrusive moral strength. Perhaps this is what Mother Ann Lee, the founder of the American Shakers, called "the inner spirit."

Maybe the Shakers have it right and always have. A life of directedness, simplicity, beauty, and devotion to a female/male god. A life of harmony within. A life lived in a state of grace.

So if you travel to Maine by car and find yourself north of the town of Gray on Route 81, look for the village of Sabbathday Lake. It is to your right, just at the crest of a hill. You will see the distinctive main dwelling house. Stop and pull into the

driveway. Pause there a moment before exploring this unique enclave. Listen to the sounds of a life dedicated to spiritual ideals. Meet the sisters and brothers of this last of the active Shaker communities. Count yourself lucky, for you are witnessing something unique.

For Sister Francis, Sister June, Brother Arnold, Brother Wayne, and David and Michael, who continue to do God's work, I thank you for your gifts to me. May it all continue, with His blessing.

STEPHEN GUION WILLIAMS

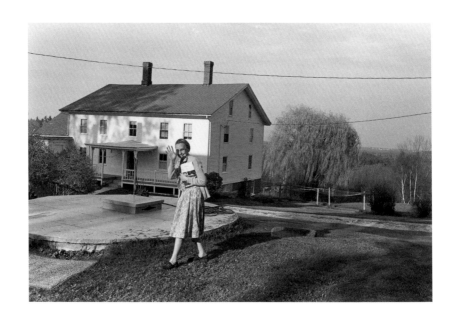

Sister Mildred Barker, 1972

ACKNOWLEDGMENTS

A Place in Time took many years to produce. It involved help and encouragement from family, friends, and many other folks. I am unable to say thanks to all of you individually on this page though I am compelled to say a special thanks to the following people:

Paul Caponigro, whose statement "you don't have to ask anymore" gave me the confidence to continue my pursuit of the medium.

Stephen Perloff, who remains a constant presence in the world of photography. He was the first person I spoke with upon reentering the discipline. He has continued to be a friend and his advice has been invaluable to this volume.

Paul Emma, photographer and friend who brought me back up to speed with cameras and introduced me to the digital world.

Chuck Isaacs, collector and educator in nineteenth-century photography, gave me direction in marketing this project and made a gift to me of my only copy of a first edition of *Chosen Land*.

David Haas of Time Exposure in Kutztown, Pennsylvania, whose diligent care and creative collaboration in the darkroom produced these beautiful prints.

Katy Homans, who designed *In the Middle* and once again graciously offered her talents in helping with the design and sequencing of the images for this book.

Gerard C. Wertkin, who unhesitatingly offered, when asked,

the beautiful and carefully crafted foreword to this volume.

Dr. Peter Syre and Dr. John D'Alessandro, my friends and colleagues. May life continue to present us with the unexpected.

David R. Godine, who remains consistent in his determination to publish books with intelligence and beauty.

Carl W. Scarbrough, designer at Godine, who gave this book such close attention in all phases of its production.

My stepsons, Tom and Matt, whose patience and acceptance I so very much appreciate.

My wonderful children Stephen, Mara, Guion, Bryn who kept asking me, "When are you going to take photographs again?" Finally. Thank you all for your persistence love and encouragement.

And my sister Molly. You are missed by one and all. Happy crosswords.

Stephen Guion Williams was born in New York City in 1942. *He grew up on a farm in Old Chatham, New York, home as well to the Shaker Museum and Library. He began photographing at the University of Kansas, where he was influenced by documentary and photojournalistic currents. After graduating in* 1965, *he began shooting for the* Philadelphia Evening Bulletin *and* Philadelphia Magazine, *eventually gaining national notice with a story on Chet Huntley, the former anchor of NBC News, in* Life *magazine. He worked on assignments for* National Geographic, Stern, *The Mayo Clinic, and Scott Foresman Company, among others. In* 1970 *he founded and co-directed The Photography Place in Berwyn and Philadelphia, where, over the next twelve years, exhibits of work and workshops led by Paul Caponigro, W. Eugene Smith, George Tice, and Arnold Newman began to influence his artistic interests. During that time he was associate professor of photography at Rosemount College and at the University of Delaware. His photographs documented two cultures – the American Shakers and the Canadian Inuit – and his work was published in* Chosen Land: The Sabbathday Lake Shakers *(with an afterword by Sister Mildred Baker) and* In the Middle: The Eskimo Today *(with an introduction by Edmund Carpenter), both published by Godine. His photographs have been exhibited nationally and internationally and have been included in the permanent collections of the University of Michigan Library, the Haverford College Library, and the Cleveland Art Museum, as well as numerous museum and institutional collec-*

tions. In 1984 he enrolled as a graduate student in psychology at Temple University, and he is currently a family therapist with KS Consultants and CCT, Inc. His most recent photographic work involves the American cowboy and the landscape and Victorian architecture of Cape May, New Jersey.

For information about exhibitions or to inquire about ordering prints of the photographs seen in this book, please send an e-mail to *stephengwilliams@comcast.net*.

A Note on the Type

A PLACE IN TIME *has been set in Fairfield, a type designed by the renowned Czech-American artist and engraver, Rudolph Ruzicka. Ruzicka's fifty-year tenure as typographic consultant to Linotype was the brainchild of the typographer and book designer, W. A. Dwiggins, who said by way of recommendation, "He knows his letters to the bone." Originally released in 1940, Fairfield is clearly a twentieth-century face, though its descent from the "modern" faces of Bodoni and the Didots is abundantly evident. Suitable for text and display (thanks to the later addition of heavier weights) Fairfield is a truly elegant type, yet its decorative qualities do not detract from its readability.*

DESIGN AND COMPOSITION BY CARL W. SCARBROUGH